Wildlife
Photographer
of the Year
Diary 2014

Published by the Natural History Museum, London

December – January

30 Monday

31 Tuesday

New Year's Eve
Hogmanay (Scotland)

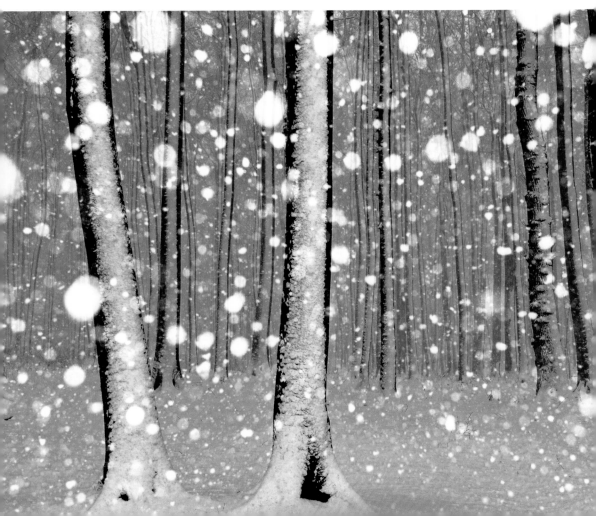

1 Wednesday

New Year's Day
Holiday (UK, Rep. Ireland, USA, Canada, Australia, New Zealand)
New moon ●

2 Thursday

Holiday (Scotland, New Zealand)

3 Friday

4 Saturday

5 Sunday

The magical forest
by Sandra Bartocha
Gespensterwald (ghostly forest) is an old beech forest, buffeted by winds from the Baltic Sea, near Nienhagen, Germany. 'I'd always imagined a dreamy image with a lot of out-of-focus flakes in the foreground and this was the perfect situation. It was quite dark by the time it began to snow very heavily, so I adjusted my camera settings to create the surreal composition of trees disappearing into a curtain of magical snowflakes.'

6 Monday

Epiphany (Christian)

7 Tuesday

8 Wednesday

9 Thursday

Illusion
by Stefano Unterthiner
Chaos reigned at a winter gathering of whoopers on Lake Kussharo,
Hokkaido, Japan. The rhythm of the flock's movements is captured, creating
an illusion of one swan seen at different points in time. The swan enters
lower right, wanders around, sits down a few times, and exits top right – a
single shot of continuous time and motion. Whooper swans migrate great
distances between their wintering and breeding grounds, congregating in
flocks of up to 3,000 birds.

10 Friday

11 Saturday

12 Sunday

January

13 Monday

14 Tuesday

Makar Sankrant (Hindu)

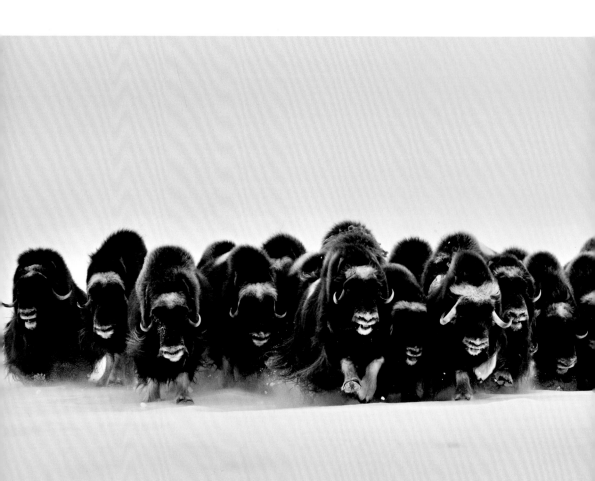

15 Wednesday

16 Thursday

Full moon ○

17 Friday

18 Saturday

Milad un Nabi, Birthday of the
Prophet Muhammad (Islamic)

19 Sunday

The charge

by Eric Pierre

Eric had been tracking Arctic wolves on Victoria Island, Canada, when his guide spotted a herd of muskoxen moving. The herd was visibly nervous, possibly because of nearby wolves. Eric made a big loop to position himself just in front of the running herd, 'It was one of those situations where I had to make a choice between technical accuracy, aesthetics – and security.' Muskoxen live only in Arctic tundra and are well-adapted to their extreme environment with insulated coats and broad hoofs.

20 Monday

21 Tuesday

22 Wednesday

23 Thursday

Trust
by Klaus Echle
Klaus gained the trust of this female fox over several months, regularly
walking in the part of the Black Forest, Germany, where she hunted. The
best time to see her, when she was most self-assured, was when the weather
was bad and fewer people were around. At the start of the mating season
the vixen disappeared. 'I still miss seeing her,' he says. 'She came to trust me
completely, and that's what I wanted to capture in this picture.'

24 Friday

25 Saturday
Burns Night (Scotland)

26 Sunday
Australia Day

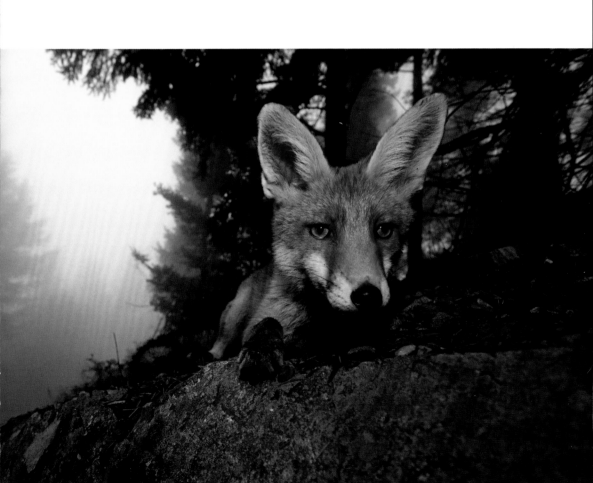

27 Monday

Holocaust Memorial Day
Australia Day, Holiday (Australia)

28 Tuesday

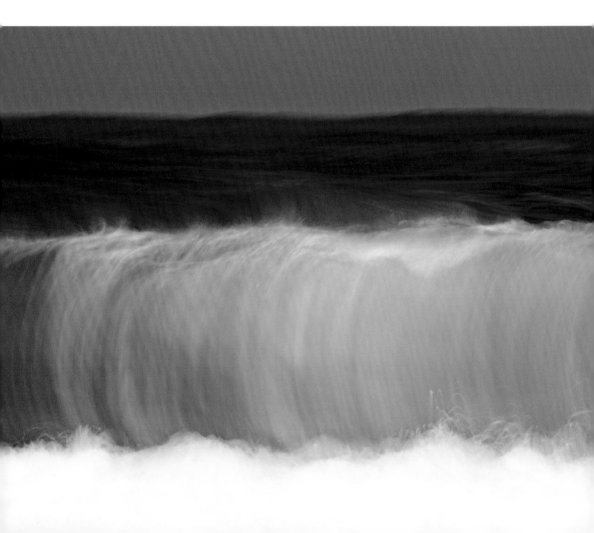

29 Wednesday

30 Thursday

New moon ●

31 Friday

Chinese New Year (Year of the horse)

1 Saturday

2 Sunday

Ocean abstraction
by Laurence Norton
'I could feel the impact in my chest,' Laurence says, as winter storm waves slammed onto Kauai's north shore in Hawaii. Using a long lens to achieve a compression of the space between the waves and the ocean behind, a slow shutter speed to soften the motion and filters to adjust light and colour, he achieved his objective: to create an abstraction of the power of ocean waves and the serenity of the ocean itself.

3 Monday

4 Tuesday

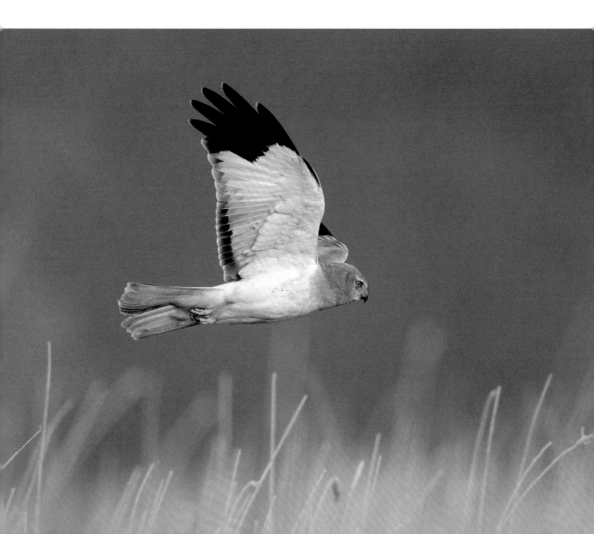

5 Wednesday

6 Thursday

Waitangi Day (New Zealand)

7 Friday

8 Saturday

9 Sunday

Hunting harrier
by Marc Slootmaekers
'I spend almost all my free time at the Kalmthoutse Heide, one of the biggest nature reserves in Flanders, Belgium. I knew this bird's routine, so one cold winter morning I built my hide in its path. This almost monochrome picture is my favourite.' Hen harriers prefer to live near open patches of land with low vegetation across the northern part of the northern hemisphere. When they hunt for small mammals and birds they glide low over the fields to surprise their prey.

10 Monday

11 Tuesday

12 Wednesday

13 Thursday

Cuttlefish glow
by Chris Gug
'While diving in Bunaken National Park, Indonesia, I came across this
broadclub cuttlefish. I could see the intelligence in its eyes as it seemed
to examine everything about me. That or it was simply a matter of vanity,
entranced by its own reflection in my camera lens.' Broadclub cuttlefish
display a range of colours and textures for communication with other
cuttlefish or to camouflage themselves from predators. Commonly they
are light brown or yellowish with white mottled markings.

14 Friday

St Valentine's Day
Full moon ○

15 Saturday

16 Sunday

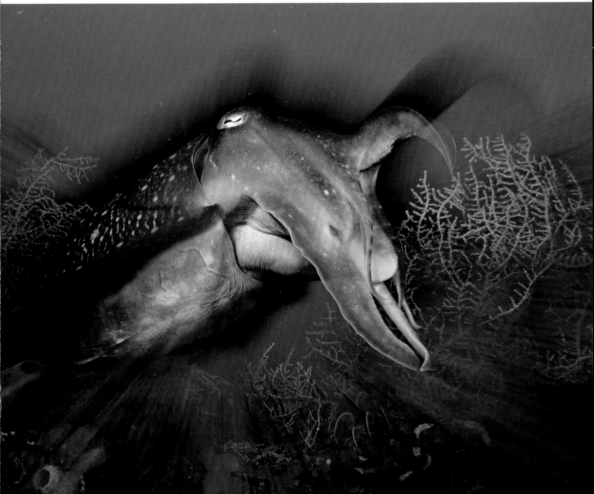

17 Monday

18 Tuesday

19 Wednesday

20 Thursday

False killers, disguised dolphin
by Clark Miller
'False killer whales are normally very cautious and seldom approach divers,'
says Clark, which is why close-up photos are rare. But during a trip to
Dominica to observe sperm whales these individuals found something
fascinating about him. Then in the mélange, he saw a dolphin – and realised
he had the chance of a very special shot. Scientists have long known that
bottlenose dolphins can associate with false killer whales, but this is probably
the first time the relationship has been photographed.

21 Friday

22 Saturday 23 Sunday

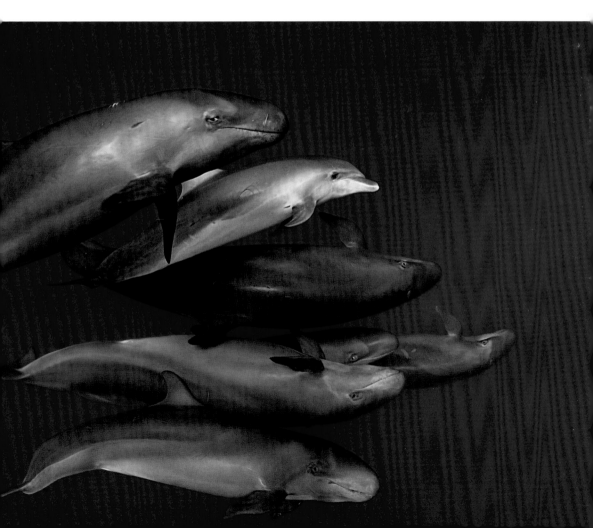

24 Monday

25 Tuesday

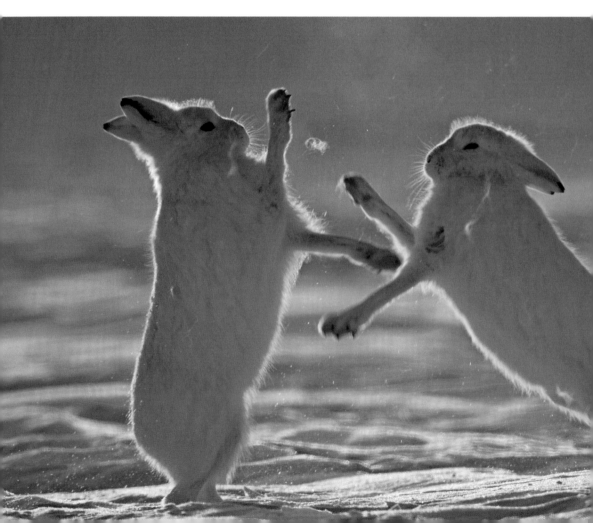

26 Wednesday

27 Thursday

28 Friday

1 Saturday

2 Sunday

Hare spat
by Morten Hilmer

'I took a job as a cook at an isolated weather station in Greenland. In my spare time, I visited the mountains, getting to know the local hares. Unlike the hares, I had plenty of rations. So, while our dogs dozed, the hares pinched their food.' Arctic hares live in the harsh environment of the North American tundra. They survive in winter by scraping away the snow to reach woody plants, mosses, lichens and roots, and fights often break out.

3 Monday

4 Tuesday

Shrove Tuesday (Christian)

5 Wednesday

Ash Wednesday (Christian)

6 Thursday

Hare sitting tight
by Klaus Tamm
Klaus and his son Paul were walking near their home in Wuppertal, Germany,
when 'Suddenly Paul gestured to me. It took me a minute to see the hare
camouflaged in the grass. I was thrilled, as hares are no longer common
where we live.' The European hare moults twice a year. In summer its fur is
brown and in winter the hare's coat goes grey. But, for all hares, moulting
time is triggered by the number of hours of daylight.

7 Friday

8 Saturday

9 Sunday

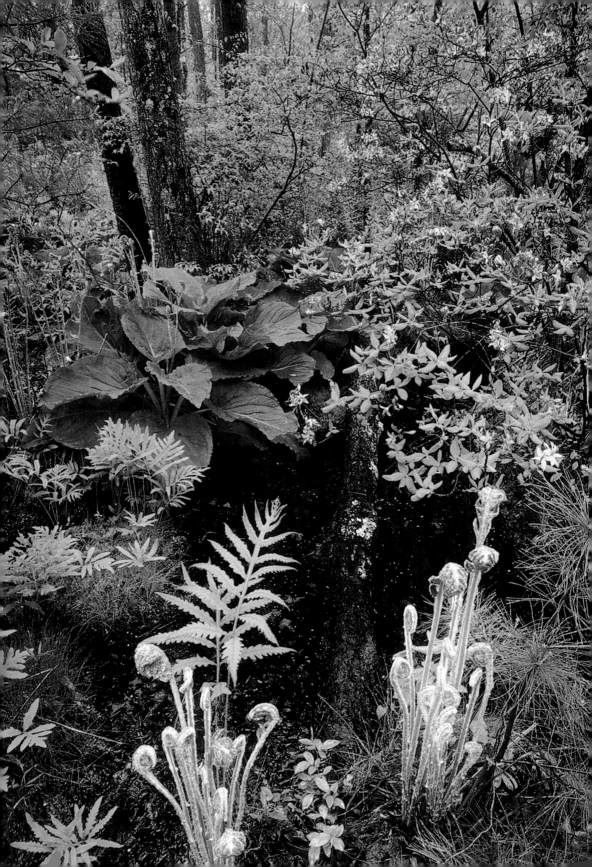

March

10 Monday

11 Tuesday

12 Wednesday

13 Thursday

14 Friday

15 Saturday

16 Sunday Full moon ○

Wild spring garden
by Floris van Breugel
'It took me several days of wandering through mosquito-filled, knee-deep swamps
before I finally found this composition, so perfect it was as if someone had planted it
as their garden.' Sapsucker Woods in Ithaca, New York State is a sanctuary for forests,
ponds, ferny swamps and abundant wildlife. Cinnamon ferns, sensitive ferns and
Rhodora rhododendrons are found in bogs, swamps and damp woodland.

March

17 Monday

St Patrick's Day, Holiday (N. Ireland, Rep. Ireland)

18 Tuesday

19 Wednesday

20 Thursday

Spring Equinox

21 Friday

22 Saturday 23 Sunday

Grass strokes
by Georg Kantioler
'I took my time to arrange the shot, sometimes changing my position by a matter of just a few millimetres, until I had smooth pastel shades and the tender, peaceful picture I was after. I often search for simple motifs. I'm not interested in finding rare plants or animals. I like to show the quiet beauty of everyday subjects.' This delicate foxtail grass was found one warm, sunny spring morning in dry grassland near Georg's home in the South Tyrol, northern Italy.

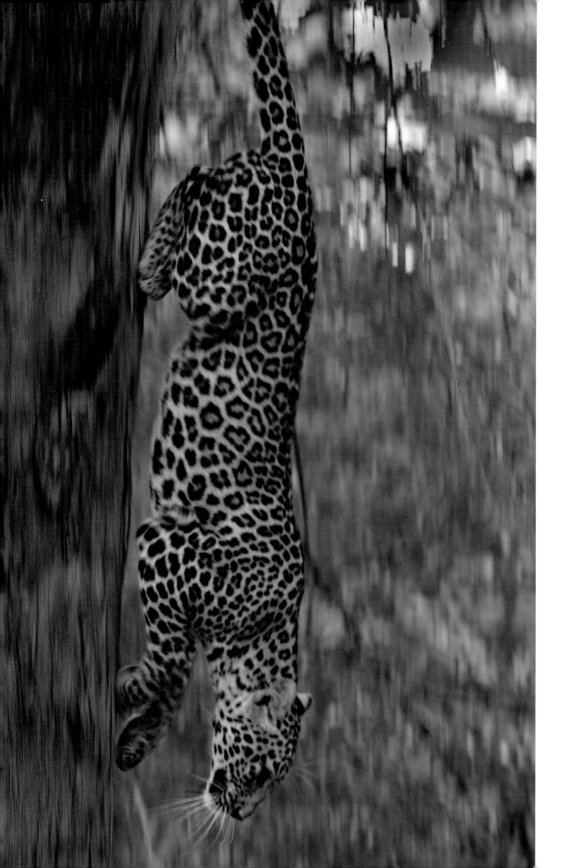

24 Monday

25 Tuesday

26 Wednesday

27 Thursday

28 Friday

29 Saturday

30 Sunday

Mothering Sunday (UK, Rep. Ireland)
British Summertime begins (BST)
New moon ●

Leopard descending
by Ajit K Huilgol
'I was driving along a twisty track in Nagarhole National Park in southern India, and didn't see the leopard until I was almost at the tree. It swept straight down the trunk with a grace that was truly sublime.' Leopards are adept and powerful climbers. They often drag the bodies of animals much larger than themselves into trees to protect them from scavengers such as hyenas.

31 Monday

1 Tuesday

2 Wednesday

3 Thursday

The orphans

by Mark Leong

Orangutans confiscated from circuses, sideshows and private owners in Kalimantan, Indonesia, are taken in by the Borneo Orangutan Survival Foundation. The orphans go to 'forest school' – the rainforest – where they can practise skills such as climbing and learn which plants are edible. 'The hardest part of the shoot,' says Mark, 'was resisting the urge to play with the little ones, because they are so social, curious and adorable.' The greatest threats to their survival are habitat loss and the illegal pet trade.

4 Friday

5 Saturday 6 Sunday

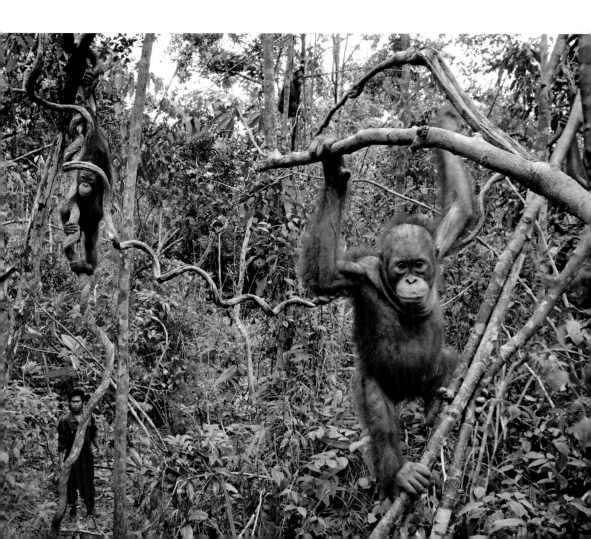

7 Monday

8 Tuesday

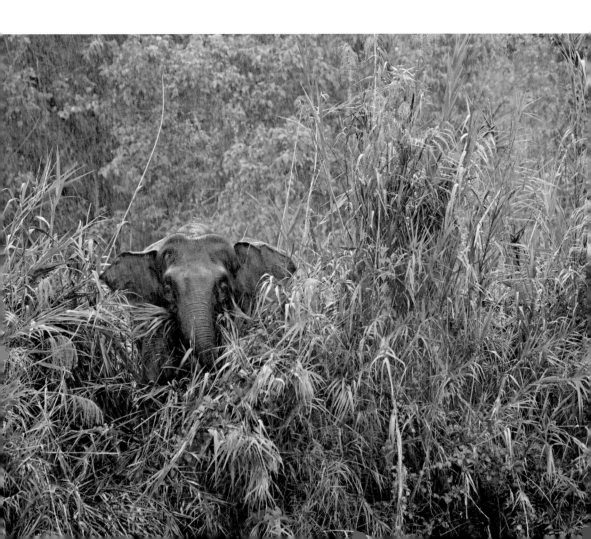

9 Wednesday

10 Thursday

11 Friday

12 Saturday

13 Sunday

Elephant onlooker
by Juan Carlos Muñoz
'As I travelled by boat down the river in Borneo, the heavens opened. I couldn't decide what worried me more, the boat sinking or protecting my camera. Suddenly the undergrowth parted and a male pygmy elephant looked out, munching on leaves and watching the chaos serenely.' Using DNA evidence, pygmy elephants were provisionally classified as a subspecies of the Asian elephant in 2003. They are found only on the island of Borneo, where they live in the thick forests, and are critically endangered.

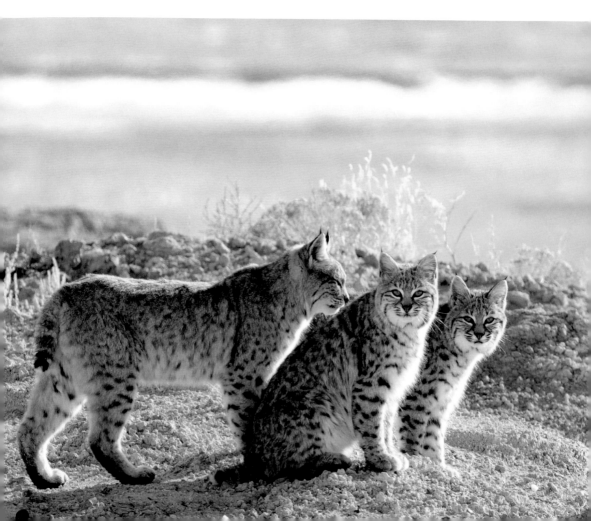

April

14 Monday

15 Tuesday

First day of Passover (Jewish)
Full moon ○

16 Wednesday

17 Thursday

Maundy Thursday (Christian)

18 Friday

Good Friday (Christian)
Holiday (UK, Rep. Ireland, Canada, Australia, New Zealand)

19 Saturday

20 Sunday

Easter Sunday (Christian)

Spirit of the Badlands
by Joe Sulik
Thrilled at a brief sighting of the elusive bobcat in Badlands National Park, South Dakota, USA, Joe spent three days searching for another. He finally saw one catch a prairie dog far out across the grassland. While watching carefully to see where it then went, Joe saw 'two cubs appear from behind a rocky bluff to greet their mother. After a short moment of reunion, all three cats disappeared over the bluff.' Bobcats are solitary animals, and females raise their young alone.

April

21 Monday

Easter Monday (Christian)
Holiday (UK excl. Scotland, Rep. Ireland, Canada, Australia, New Zealand)
Queen Elizabeth II's Birthday

22 Tuesday

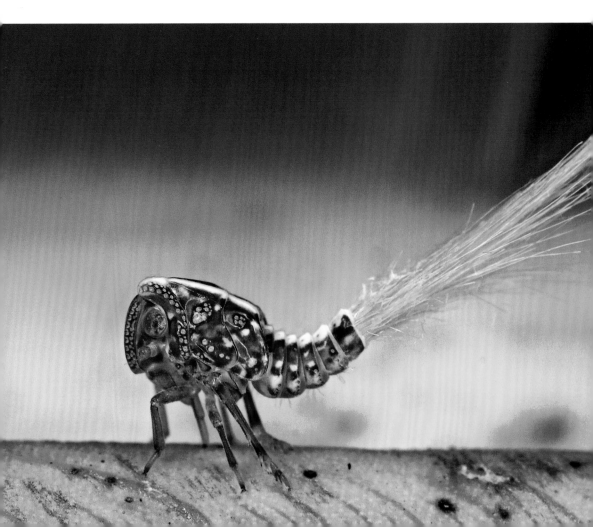

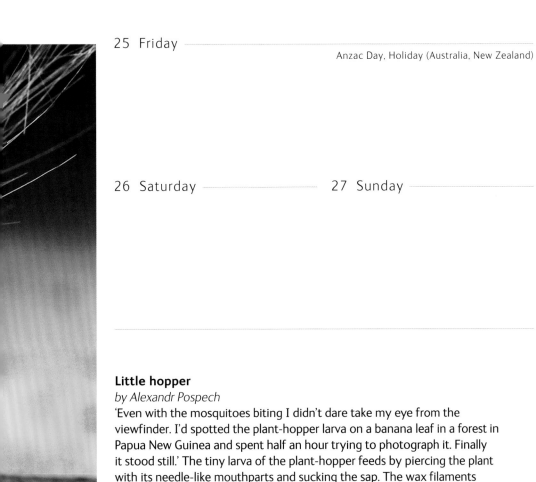

23 Wednesday

St George's Day (England)
Last day of Passover (Jewish)

24 Thursday

25 Friday

Anzac Day, Holiday (Australia, New Zealand)

26 Saturday

27 Sunday

Little hopper
by Alexandr Pospech
'Even with the mosquitoes biting I didn't dare take my eye from the viewfinder. I'd spotted the plant-hopper larva on a banana leaf in a forest in Papua New Guinea and spent half an hour trying to photograph it. Finally it stood still.' The tiny larva of the plant-hopper feeds by piercing the plant with its needle-like mouthparts and sucking the sap. The wax filaments produced from its rear end may serve to confuse or distract predators.

April – May

28 Monday

29 Tuesday

New moon ●

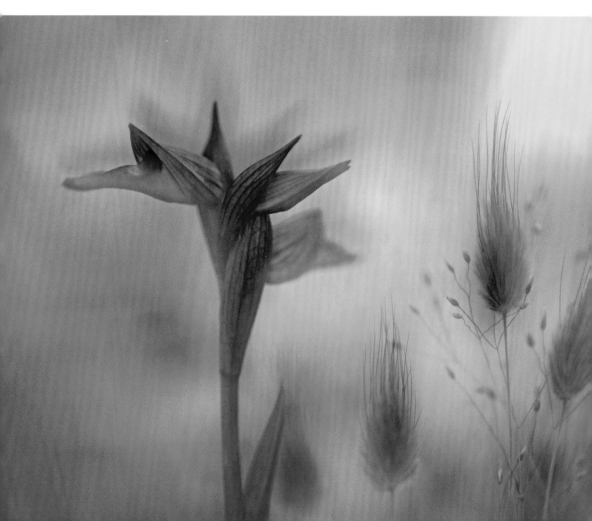

30 Wednesday

1 Thursday

2 Friday

3 Saturday 4 Sunday

Tongue orchid and hare's-tail
by Sandra Bartocha
For Sandra, the lure of the Gargano peninsula in southern Italy was always its orchids. At least 69 different species grow here, and the location is famous for them. On finding a tongue orchid growing among hare's-tail and quaking grasses, she used an in-camera double exposure to keep the softness of the scene, focusing on the two different layers within the frame – the orchid and the hare's-tail. The light is purely that of the setting sun.

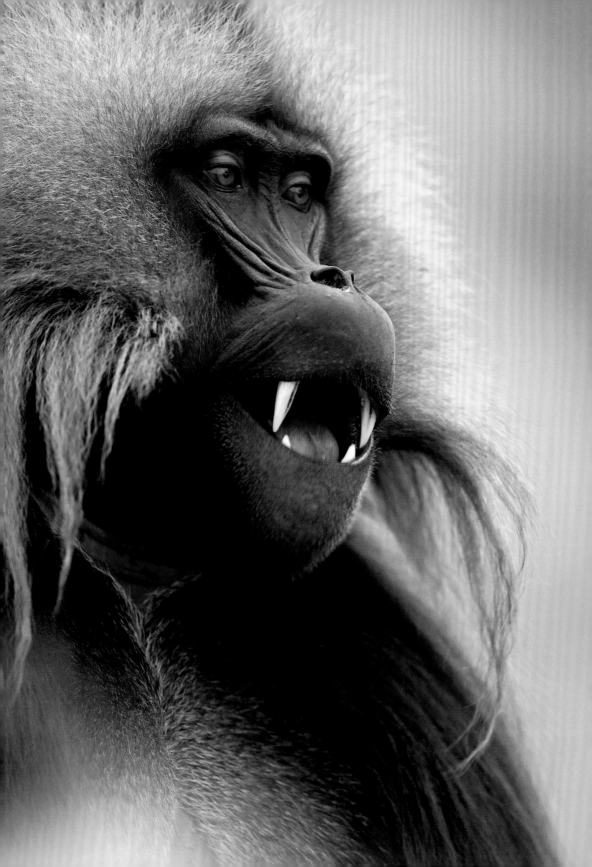

5 Monday

6 Tuesday

7 Wednesday

8 Thursday

9 Friday

10 Saturday

11 Sunday

Mother's Day (USA, Canada, Australia, New Zealand)

Ethiopian mountain king

by Joe McDonald

'A troop of geladas was making its way to the cliff edge to spend the night. In the soft light this strikingly beautiful male attracted my attention. It paused long enough for me to take a few portraits before joining its troop.' Gelada baboons are found only in Ethiopia and live high up in the highlands and mountains. They are the only surviving grass-grazing primates and spend much of their time grazing.

12 Monday

13 Tuesday

14 Wednesday

Full moon ○

15 Thursday

16 Friday

17 Saturday

18 Sunday

Leaping heron
by Thomas P Peschak
'I spotted this heron by a beach in the Seychelles, leaping for dragonflies. Its success rate could, at best, be described as fair. But it kept trying until the sun started to disappear below the horizon.' The striated heron lives in forest patches near water across the Middle East and Southeast Asia. Its diet is mainly fish but insects, frogs, molluscs and mice all make it to the menu.

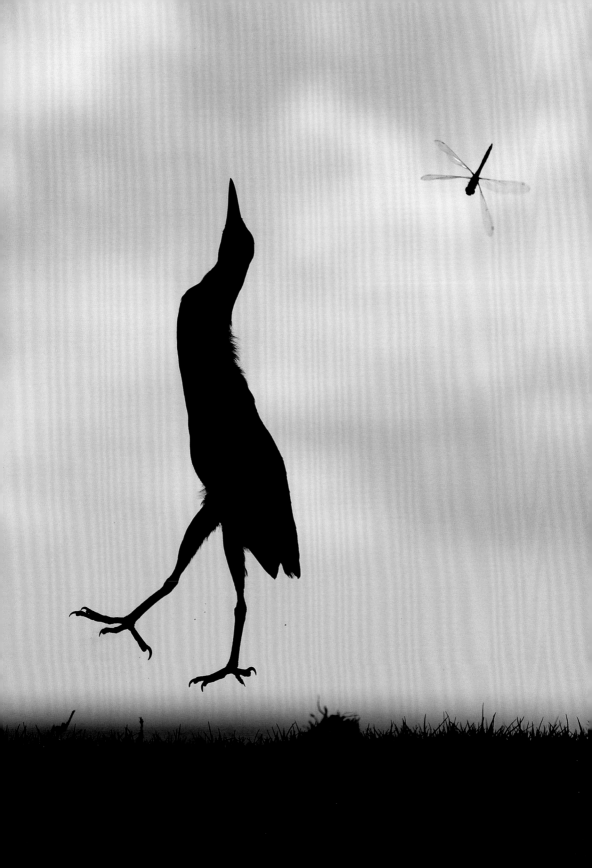

19 Monday

20 Tuesday

21 Wednesday

22 Thursday

Orchid in a flush of garlic
by Sandra Bartocha
'I photographed this tall Apulian bee orchid against the background of the sea, keeping the orchid in shadow but making use of the fantastic morning light bouncing off the glossy surfaces of the wild garlic and the water to create the sparkling setting.' These particular bee orchids are native to southern Italy. The floral scents, structures and colours of this orchid family have evolved to mimic female bees, and so attract male bees to the flowers to pollinate them.

23 Friday

24 Saturday 25 Sunday

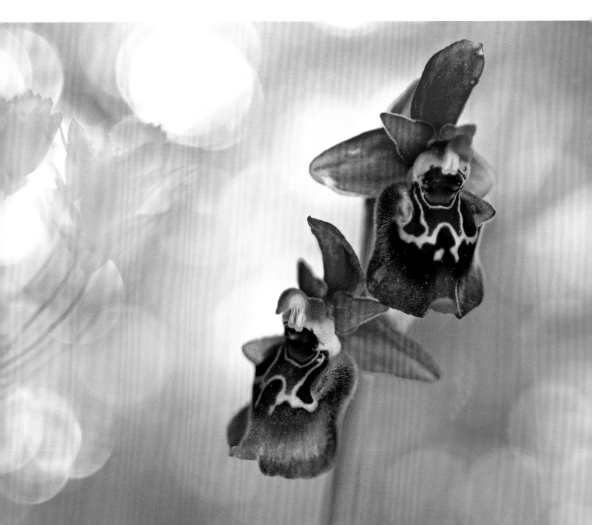

26 Monday

27 Tuesday

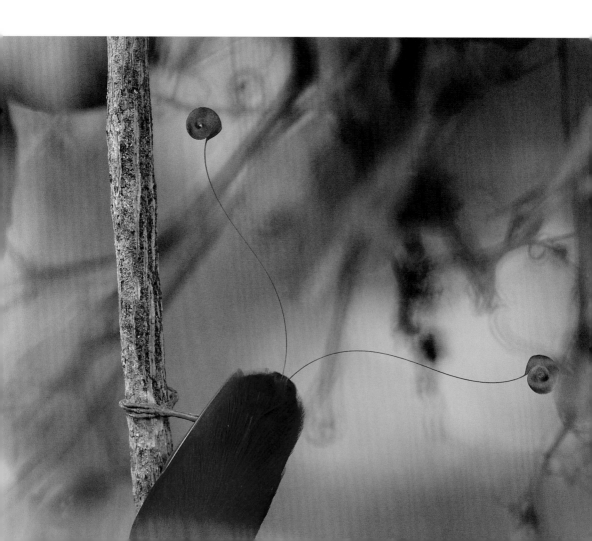

28 Wednesday

New moon ●

29 Thursday

Ascension Day (Christian)

30 Friday

31 Saturday 1 Sunday

Paradise performance
by Tim Laman
Tim has a passion for birds of paradise, and in the lowland forest at the base
of the Arfak Mountains of West Papua, Indonesia, he set out to photograph
the king bird of paradise. 'I wanted to highlight the male's distinctive
features, especially those tail wires and the blue legs contrasting with the
brilliant-red body.' The king bird of paradise is the smallest, yet most brightly
coloured, member of the bird of paradise family.

June

2 Monday

Holiday (Rep. Ireland)
Queen Elizabeth II's Birthday, Holiday (New Zealand)

3 Tuesday

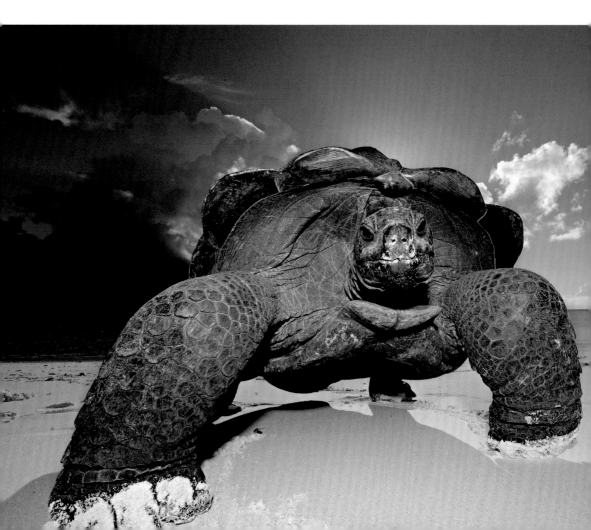

4 Wednesday

5 Thursday

6 Friday

7 Saturday

8 Sunday
Pentecost/Whitsun (Christian)

Giant beachcomber
by Thomas P Peschak
This female tortoise, who is probably at least 100 years old, regularly forages along the beach in front of a research station on Aldabra in the Seychelles. 'The moment I took the shot, I had to roll out of its way to avoid the enormous animal clambering right over me.' Aldabra giant tortoises normally graze on low-level vegetation and will cover surprising distances in search of food, often wandering onto the beaches to eat washed-up seedpods.

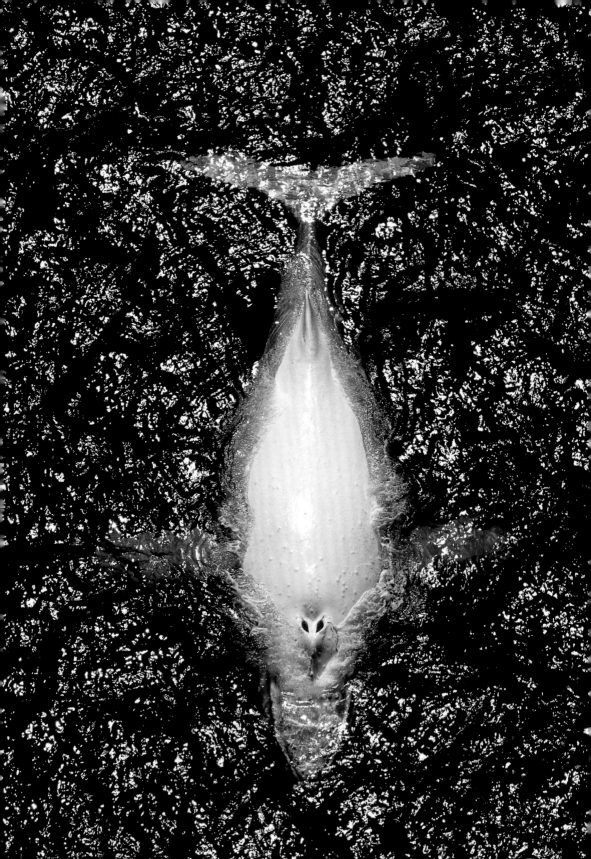

9 Monday

10 Tuesday

11 Wednesday

12 Thursday

13 Friday

Full moon ○

14 Saturday

15 Sunday

Father's Day (UK, Rep. Ireland, USA, Canada)
Trinity Sunday (Christian)

White fella

by Marc McCormack

Migaloo (Aboriginal for white fella) is the world's only known all-white humpback whale. On hearing that a tour boat had spotted Migaloo off Green Island, Australia, Marc chartered a helicopter to take him directly to the spot to get a portrait from above. 'On this day the water was almost smooth,' he says. 'I captured this image as Migaloo took one last breath and disappeared like a giant ghost.'

16 Monday

17 Tuesday

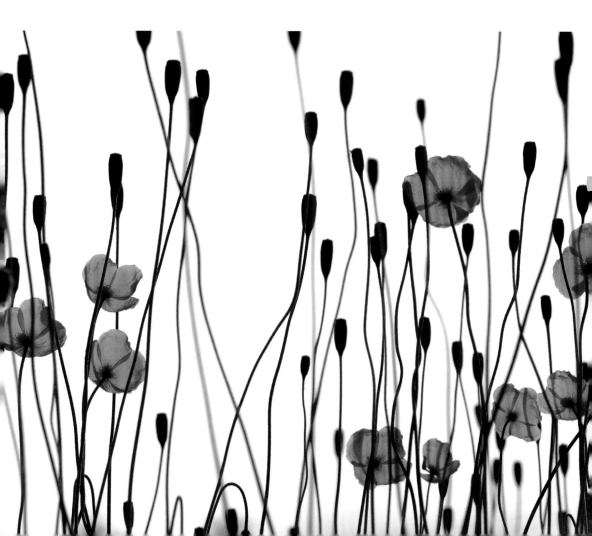

18 Wednesday

19 Thursday

Corpus Christi (Christian)

20 Friday

21 Saturday

Summer Solstice

22 Sunday

Fading beauty

by David Maitland

On a car-park embankment in Wiltshire, England, a mass of poppies appeared one day. 'I love poppies,' says David, 'and I can't resist photographing them. It's hard to think of another plant that's so fleetingly beautiful . . . But when poppies flower en masse, it's almost too much, and it's hard to capture the ephemeral nature of their beauty.' From a prone position, he shot them against an overcast sky to create an architecture of stems 'with little flashes of brilliance'.

June

23 Monday

24 Tuesday

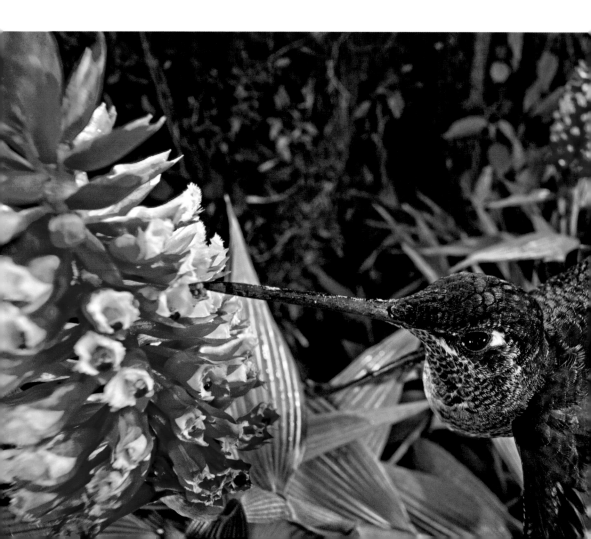

25 Wednesday

26 Thursday

27 Friday

New moon ●

28 Saturday
Ramadan begins (Islamic)

29 Sunday

Sweet intimacy
by Christian Ziegler
'Luckily, after two weeks of watching hummingbirds pass by, one finally paused and my custom-made wide-angle macro lens produced this wonderful image, capturing the nectar for pollination exchange in intimate detail.' In the high-altitude cloud forest of Cerro Punta, western Panama, there are few insect pollinators so orchids must entice hummingbirds with offers of nectar. Hummingbirds dip their beaks into the orchid's open florets, drink, and then transport a pollen package to the next orchid they visit.

June – July

30 Monday

1 Tuesday

Canada Day, Holiday (Canada)

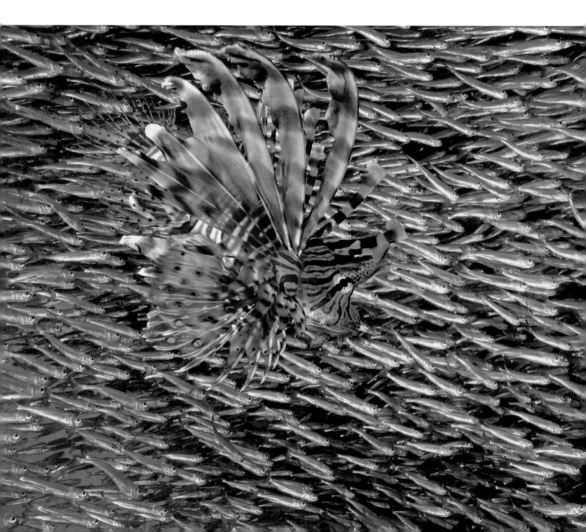

2 Wednesday

3 Thursday

4 Friday

Independence Day, Holiday (USA)

5 Saturday

6 Sunday

Lion among the shoal
by Alex Tattersall
Alex encountered a huge school of baitfish at Marsa Nakari, Egypt, 'The shimmering ball of fish', he says, 'swallowed up my next three hours'. Local predators soon arrived, including a common lionfish, which lunged at the baitball, picking off individuals and swallowing them whole. Alex concentrated on highlighting the contrast between the striking, venomous lionfish and the silvery shoal. The lionfish's ornate fins and red-and-white zebra stripes warn of its highly poisonous spines.

7 Monday

8 Tuesday

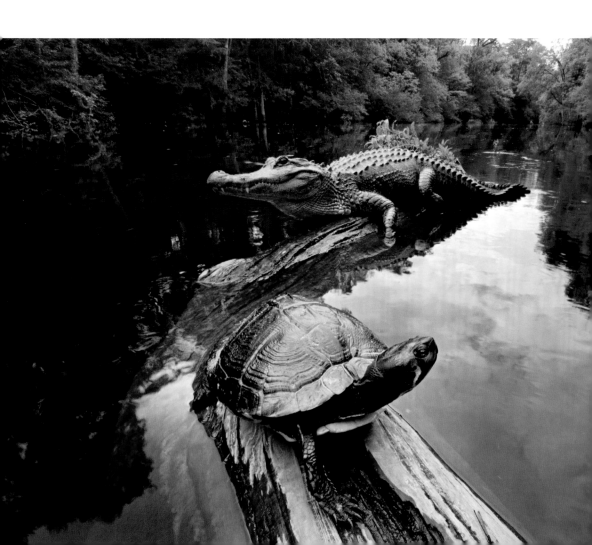

9 Wednesday

10 Thursday

11 Friday

12 Saturday

Full moon ○

13 Sunday

Swamp heaven
by Mac Stone
Mac was photographing one of the world's largest stands of virgin cypress and tupelo trees in Francis Beidler Forest, South Carolina, when 'I discovered a log that was a magnet for sunbathers. Every time I got close, they slipped into the water, so I mounted my camera on the log and programmed it to take a picture every ten minutes. When I returned late each afternoon I found a constant stream of American alligators and yellow-bellied sliders in swamp heaven under the sun.'

July

14 Monday

Battle of the Boyne, Holiday (N. Ireland)

15 Tuesday

St Swithin's Day (Christian)

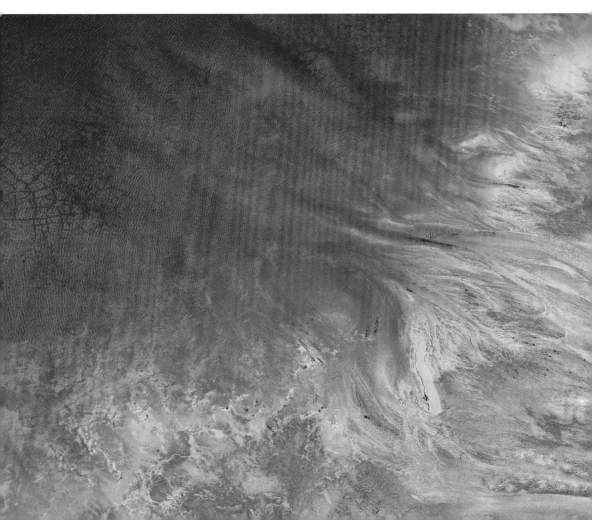

16 Wednesday

17 Thursday

18 Friday

19 Saturday

20 Sunday

Nature's canvas
by Francisco Mingorance
While flying 500 metres above the ground Francisco took this image,
'I had to measure light, adjust the camera settings and compose images
in fractions of a second, all the while fighting nausea and clinging to my
camera in the strong wind.' Natural acidity and hundreds of years of mining
have created this canvas. Mineral ores oxidise when they come into contact
with the air, staining the water and surrounding land of the river Rio Tinto,
Spain, shades of red, orange and brown.

July

21 Monday

22 Tuesday

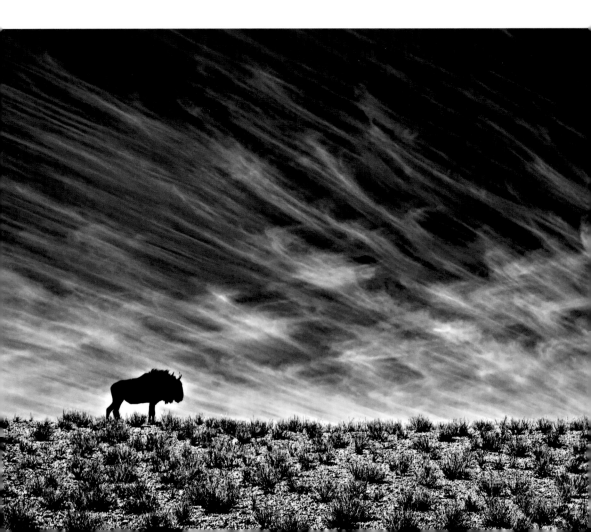

23 Wednesday

24 Thursday

25 Friday

26 Saturday 27 Sunday

New moon ●

Desert survivor
by Morkel Erasmus
It was a particularly quiet day in the Kalahari Desert, South Africa, when
a lone blue wildebeest wandered into this scene and posed against the
dramatic backdrop of streaked and cirrus clouds. 'I wanted to celebrate the
wildebeest as a desert survivor caked in dust, constantly on the search for
food and water, dodging the onslaught of predators.' Males separate from
their herds and become solitary when they are about four years old and
attempt to win a territory.

28 Monday

29 Tuesday

30 Wednesday

31 Thursday

1 Friday

2 Saturday

3 Sunday

Family tree
by Paul Goldstein
'Over the past 20 years, I have probably spent more time with cheetahs than any
other animal, but I've never seen a scene like this before,' says Paul. Having followed
this cheetah family in Kenya's Masai Mara for two weeks he caught up with them in
a balanites tree just before sunrise, 'I love the way the postures are all different – and
the indifference of the cub on the ground.'

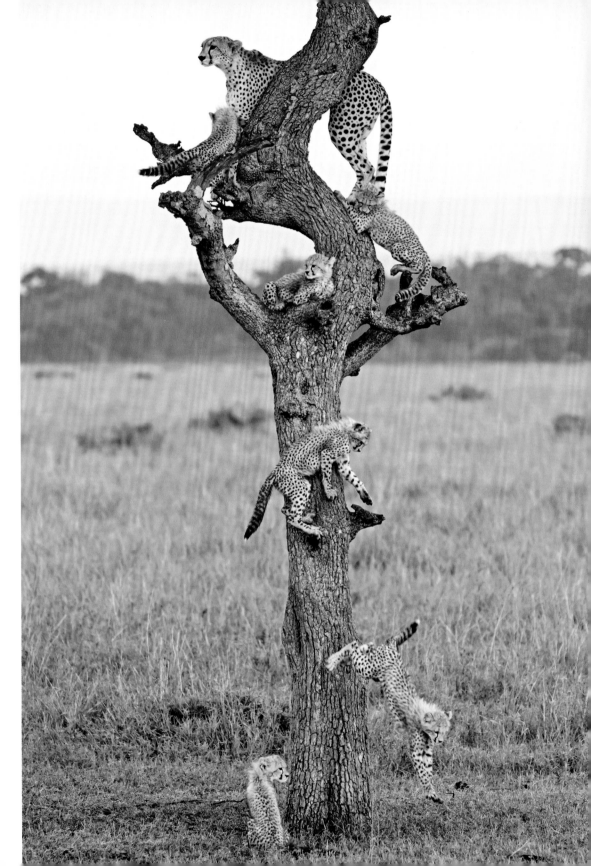

4 Monday

5 Tuesday

6 Wednesday

7 Thursday

A marvel of ants
by Bence Máté
'These leaf-cutter ants proved to be wonderful subjects,' says Bence, who discovered that they were most active at night. He would follow a column as it fanned out into the Costa Rican rainforest, terminating at a shrub, tree or bush. 'The variation in the size of the pieces they cut was fascinating – sometimes small ants seemed to carry huge bits and bigger ones just small pieces. I love the contrast between the simplicity of the shot and the complexity of the behaviour.'

8 Friday

9 Saturday 10 Sunday

Full moon ○

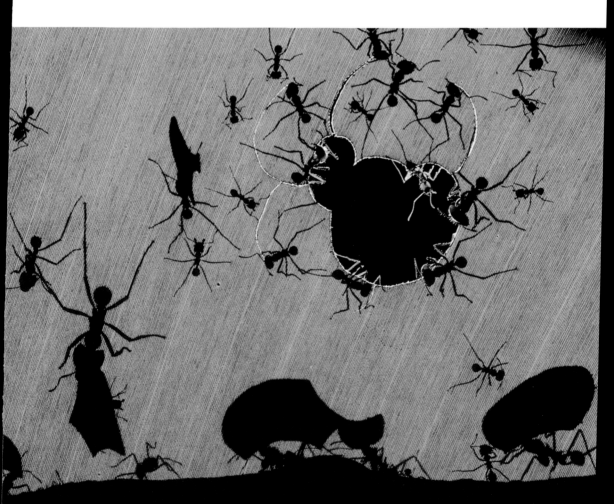

11 Monday

12 Tuesday

13 Wednesday

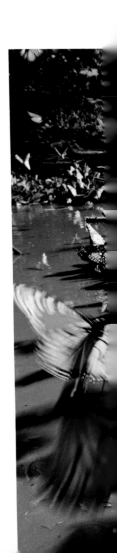

14 Thursday

A miracle of monarchs
by Axel Gomille
'Millions of monarch butterflies spend the winter at this forest site in central Mexico. The sheer density was unbelievable, it was breathtaking. They landed on my fingers, my cap, my camera – everywhere.' Monarch butterflies migrate huge distances between North America and Mexico to escape cold winters, covering almost 80 kilometres a day. Remarkably the butterflies that arrive in Mexico for the winter have never been there before – there are four lifecycles between butterflies leaving the north and arriving in the south.

15 Friday

16 Saturday

17 Sunday

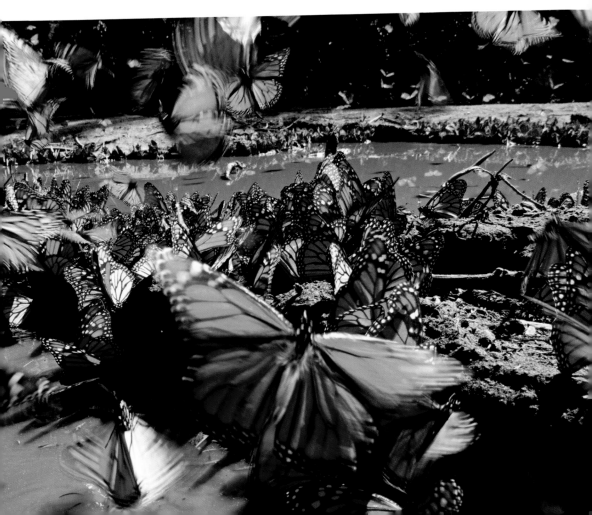

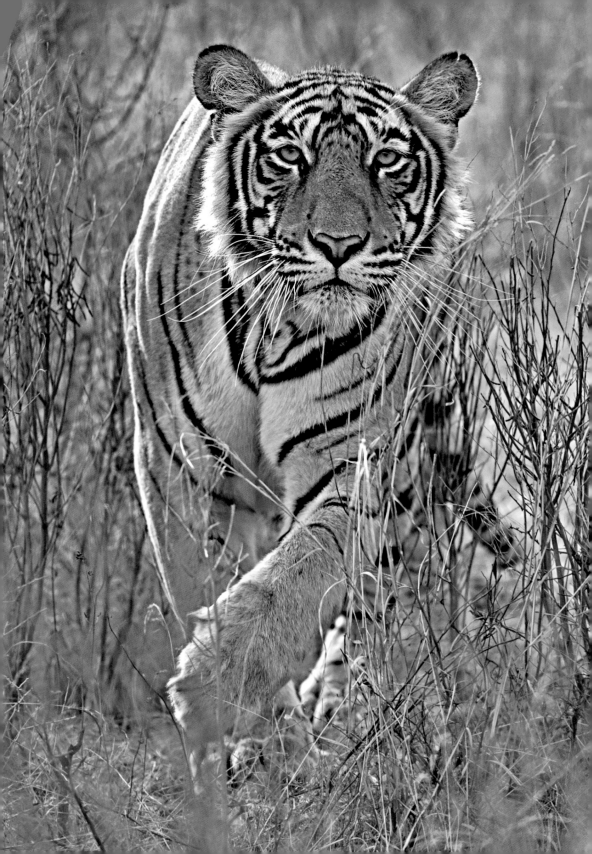

18 Monday

19 Tuesday

20 Wednesday

21 Thursday

22 Friday

23 Saturday

24 Sunday

Tiger stalking
by Andy Rouse
This young tigress stalked a herd of chital deer for a couple of hours through the
long grass in Ranthambore National Park, India, while Andy stalked her. She followed
the herd for more than a kilometre, constantly surveying for any sign of weakness or
injury among the deer, before finally selecting her victim. 'Moments before it charged,
I took this shot.' Wild tiger numbers are at their lowest since records began.

25 Monday

26 Tuesday

27 Wednesday

28 Thursday

Lanzarote by moonlight
by Francisco Mingorance
Thirty million years ago, great slabs of the Earth's crust under the Atlantic
Ocean fractured and crumpled up to create a vast underwater mountain
range. Colossal volcanoes followed, spewing up so much magma that,
eventually, they poked up out of the sea to form the Canary Islands. 'It has
such a feeling of power, such a haunting beauty. The volcanic peaks, tubes
and craters have been eroded by wind and rain to create a jagged landscape,
full of surprising shapes and colours.'

29 Friday

30 Saturday — 31 Sunday —

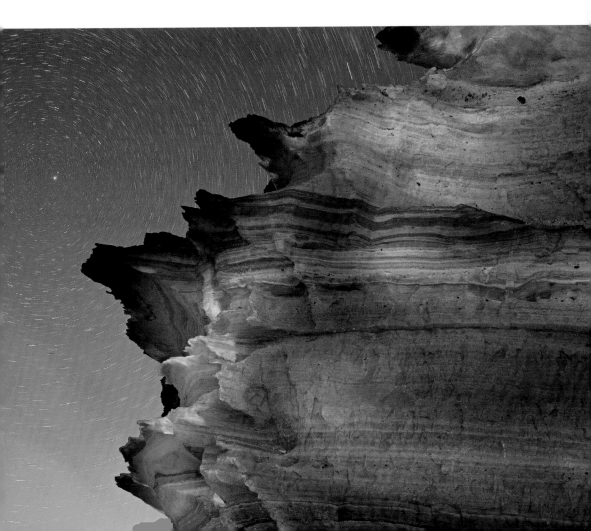

September

1 Monday

2 Tuesday

3 Wednesday

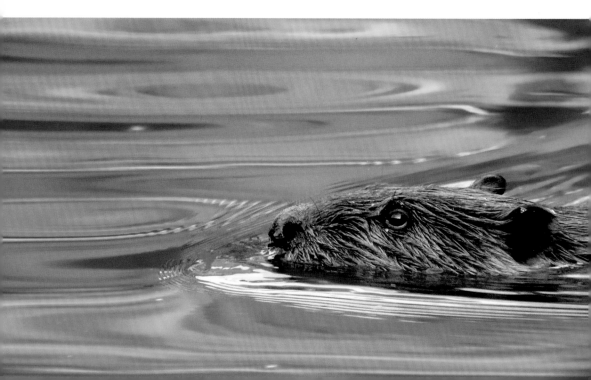

4 Thursday

5 Friday

6 Saturday

7 Sunday

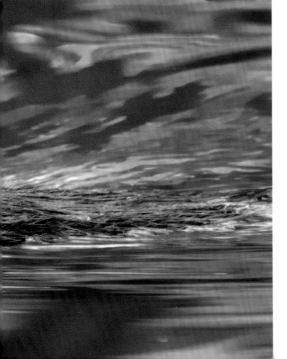

Beaver trail

by Carson Clark

'My dad and I are photographing this family of beavers on the Dry Fork River in West Virginia, USA. Evening is when they begin to get active and the light is best.' The beaver is well adapted to its watery habitat, using its flattened and scaly tail for steering and propulsion. To stop it choking when carrying sticks or gnawing underwater, it can block its throat with the back of its tongue and close its lips behind its incisors.

8 Monday

9 Tuesday

Full moon ○

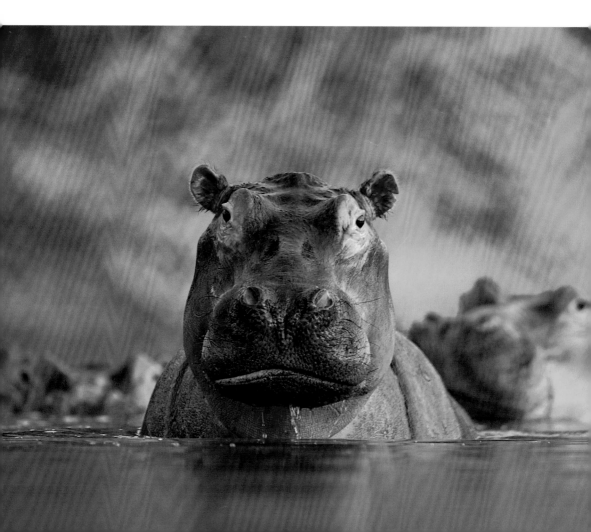

10 Wednesday

11 Thursday

12 Friday

13 Saturday 14 Sunday

Pool of hippos
by David Fettes
It was the end of the dry season, and David was lying belly-down at the edge of Long Pool in Mana Pools National Park, Zimbabwe. Hippopotamuses were arguing with each other as they vied for space – 'hurling water about,' says David, 'and giving warning yawns to each other and to me.' As he watched through his lens, the evening light illuminated the scene, and one glowing hippo rose slowly from the water.

15 Monday

16 Tuesday

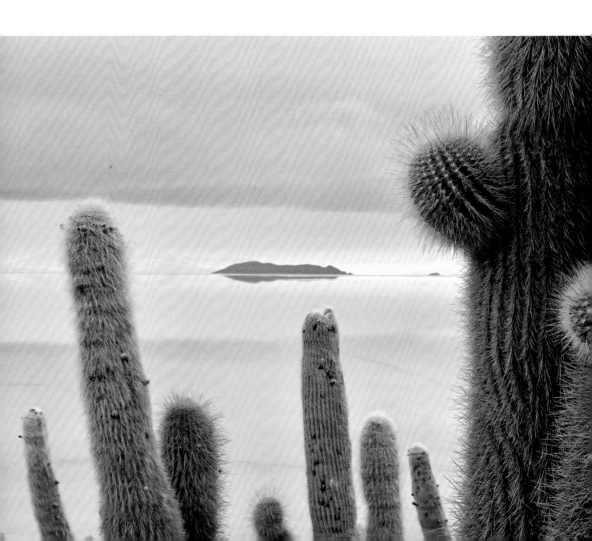

17 Wednesday

18 Thursday

19 Friday

20 Saturday 21 Sunday

Salt-desert cacti
by Jordi Busqué
'I chose to photograph the cacti in the soft light of sunrise because I wanted to show just how silent, otherworldly and vast a place this is. The shimmer of water left over from the rainy season makes the mountain seem to float on the horizon.' At 3,656 metres above sea level, Salar de Uyuni, Bolivia, is not only the world's largest salt flat, visible from outer space, but also one of the flattest places on Earth.

22 Monday

23 Tuesday

Autumn Equinox

24 Wednesday

New moon ●

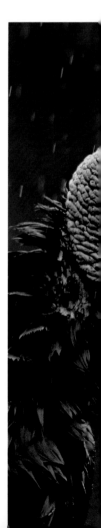

25 Thursday

Rosh Hashanah (Jewish New Year)

King of the vultures
by Bence Máté
After two months of labour, Bence's hide in northern Costa Rica was finally excavated and the king vulture banquet ready. 'I'd seen nothing but black vultures for weeks, so I went to the nearest town to see if I could scrounge a carcass that might attract a king. A sympathetic butcher gave me three cow heads and the vultures turned up straight away.' The king vulture (right) has a powerful sharp beak, complete with meat-hook and a flesh-stripping tongue.

26 Friday

27 Saturday

28 Sunday

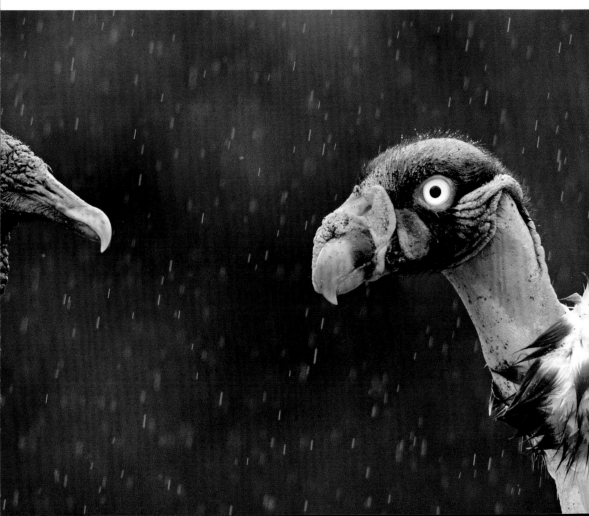

29 Monday

30 Tuesday

1 Wednesday

2 Thursday

3 Friday

4 Saturday

Yom Kippur (Jewish)

5 Sunday

Ephemeral gift
by Frédéric Demeuse
Frédéric found a clump of toadstools in Belgium's Sonian Forest. He set up his tripod
and then waited for cloudy conditions that would give him the soft lighting he wanted.
'I made the tiniest toadstool the main subject of the composition, positioning it so
that its shape was echoed by the central big one behind – a projection of what the
little one would look like very soon. It was a gift from nature.'

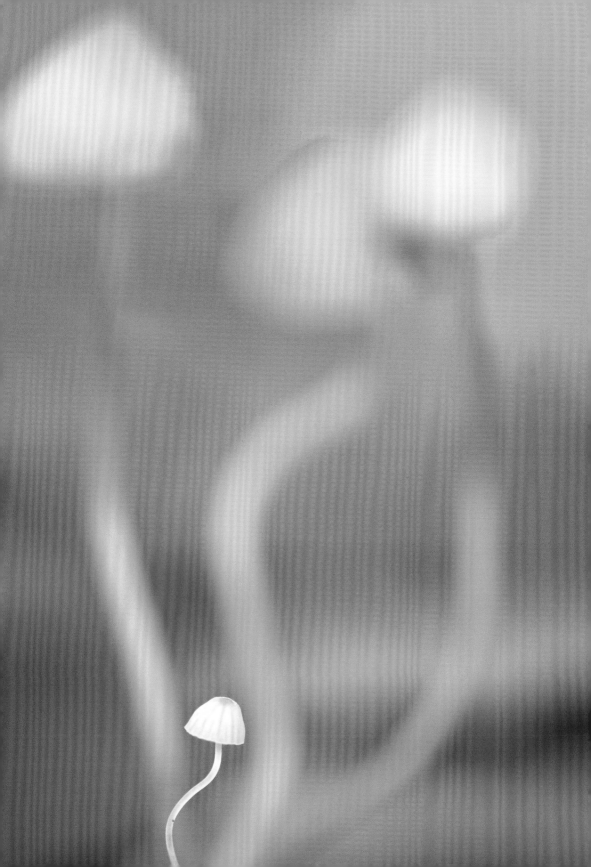

6 Monday

7 Tuesday

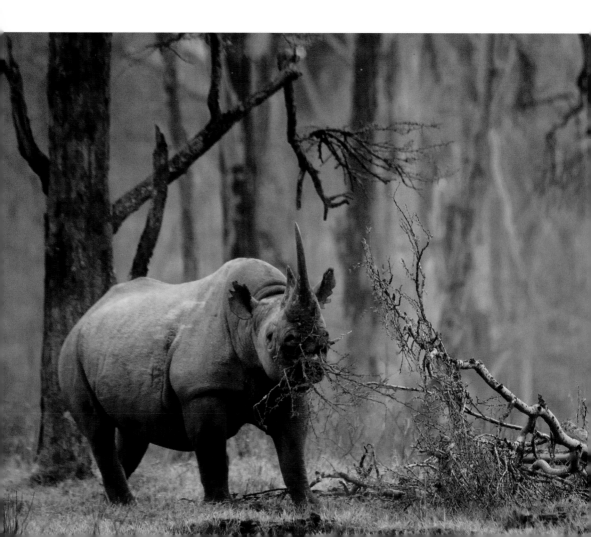

8 Wednesday

Full moon ○

9 Thursday

10 Friday

11 Saturday

12 Sunday

Golden forest rhino
by Greg du Toit
'It was a magical scene. Mist lingered in the pre-dawn glow of the sun and the forest resembled something from a children's storybook. Just then, I spotted my photographic nemesis, deep inside the forest by a fallen tree. I was so excited that I began shaking.' Large-scale poaching has devastated black rhino populations. Today many of the remaining rhinos are concentrated in fenced conservation areas, such as the Lake Nakuru National Park, where the anti-poaching laws can be enforced.

13 Monday

Columbus Day, Holiday (USA)
Thanksgiving Day, Holiday (Canada)

14 Tuesday

15 Wednesday

Al-Hijira/Islamic New Year (Islamic)

16 Thursday

The salsify canopy
by Ana Retamero

'The silky umbrellas of the salsify I spotted in southern Spain were so tightly packed it was difficult to compose an image. But then I had the idea to photograph them from the point of view of an insect. The result evokes a walk in a tiny forest.' Salsify is a common wildflower that thrives in the hot, dry Mediterranean climate. The salsify is also known as oyster plant because its root, when cooked, tastes slightly of oysters.

17 Friday

18 Saturday

19 Sunday

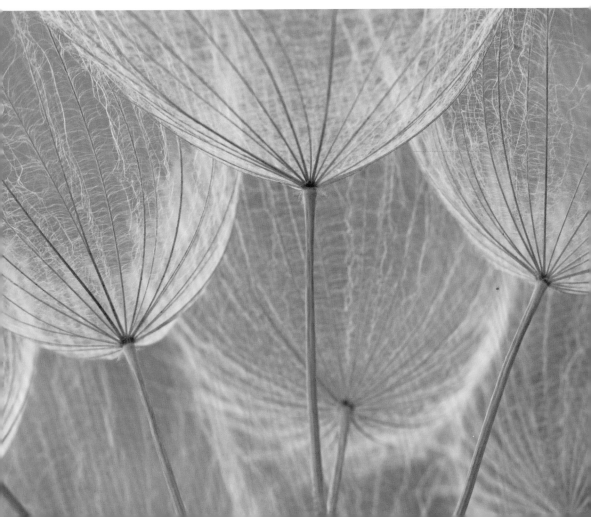

20 Monday

21 Tuesday

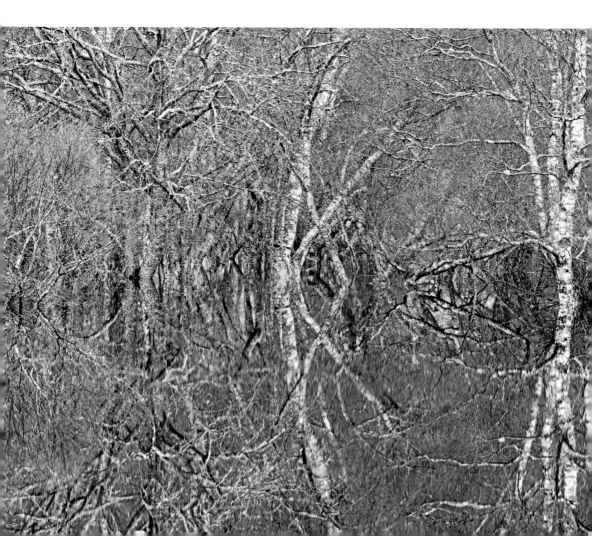

22 Wednesday

23 Thursday

24 Friday

25 Saturday

26 Sunday
British Summertime ends (BST)

Floodwater tapestry
by Peter Cairns
'I was initially attracted to this scene by the perfect reflection of the tree trunks in the still floodwater. But it was the subtle green of the lichens and the purple-tinged buds that made the scene so beautiful.' The Insh Marshes Nature Reserve, Scotland, is one of Europe's most important wetlands. Each winter, its main artery, the River Spey, spills onto the floodplain submerging the vegetation and providing a winter refuge for migratory wildfowl.

27 Monday

28 Tuesday

29 Wednesday

30 Thursday

31 Friday

Halloween (Christian)

1 Saturday

All Saints' Day (Christian)

2 Sunday

A stack of suitors
by Marcel Gubern
Marcel was on the lookout for mating turtles off the east coast of Sabah, Borneo, when he noticed a green turtle floating nearby. 'As I watched,' he says, 'I realised it was being pushed out of the water by something underneath. It was the moment I'd been waiting for . . . I couldn't believe my luck when I discovered it wasn't just two but a stack of turtles mating.'

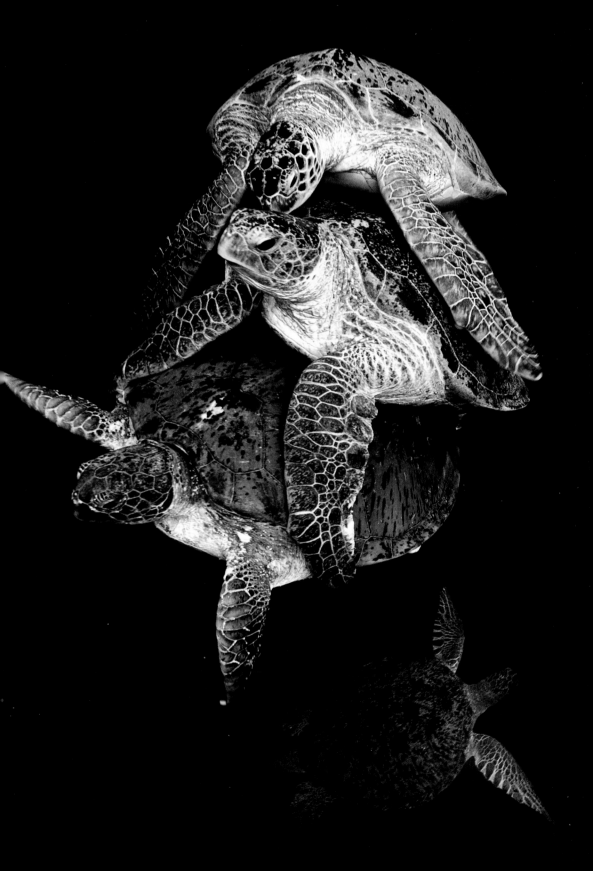

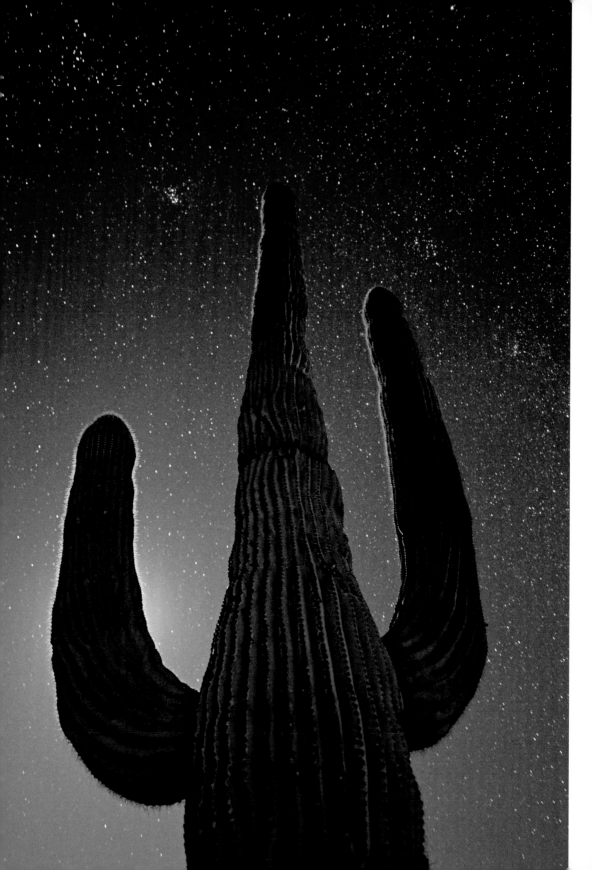

3 Monday

4 Tuesday

5 Wednesday
Guy Fawkes Night (UK)

6 Thursday
Full moon ○

7 Friday

8 Saturday

9 Sunday

Desert icon
by Chris Linder
Chris set out to capture the grandeur of this saguaro cactus, growing in the Organ
Pipe Cactus National Monument, Arizona, and 'convey the feeling of awe I felt while
walking among such giants. To achieve the star-studded background, I selected a
high ISO to keep the stars from blurring and created the halo by positioning the rising
moon behind one of the arms.' This species has a lifespan of 150 years or more.

November

10 Monday

11 Tuesday

Armistice Day
Veterans Day, Holiday (USA)

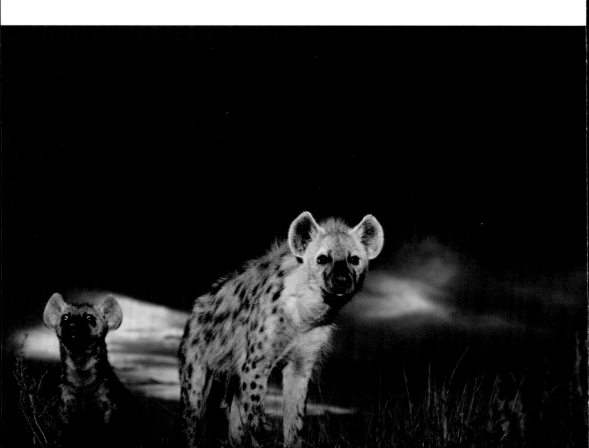

12 Wednesday

13 Thursday

14 Friday

15 Saturday

16 Sunday

The hyena squad
by Lorenz Andreas Fischer
It was the 'blue hour', when the sun had dropped below the horizon, draining the sky of reds, yellows and oranges and leaving it saturated with indigo. Lorenz had spent more than two weeks with these hyenas in a national park in Zambia, gaining the confidence of the clan. The cubs would happily play close by, 'So when this curious squad of youngsters worked out who it was lying on the ground near their den, they relaxed.'

17 Monday

18 Tuesday

19 Wednesday

20 Thursday

White-out

by Stephan Rolfes

'A sudden snowfall in Germany's Boller Moor was perfect for photography. But when fog set in I decided to concentrate on trees rather than animals. I was struck by these two snow-filled ones, and I liked the way the fog erased the horizon.' Boller Moor is part of a large flat area of managed protected moorland with lots of wild moors, grassland and peat bogs. Its mild climate also makes the area one of the richest in the country for farming.

21 Friday

22 Saturday

New moon ●

23 Sunday

24 Monday

25 Tuesday

26 Wednesday

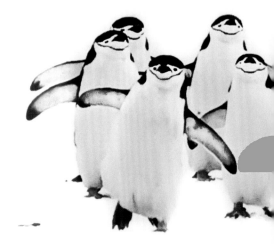

Back in, front out

by Esa Mälkönen

During his time at the penguin rookery on Deception Island in South Shetland, Antarctica, Esa became more and more fascinated with the activities of the 100,000 or so penguins. 'Even from a distance it was easy to see who was doing what. Black backs told one story, white fronts another. The challenge was to get a shot showing both the backs and fronts of the penguins in an arrangement that worked aesthetically – not too few and not too many.'

27 Thursday ———

Thanksgiving, Holiday (USA)

28 Friday ——

29 Saturday ———————————————————— 30 Sunday ——————————————

St Andrew's Day

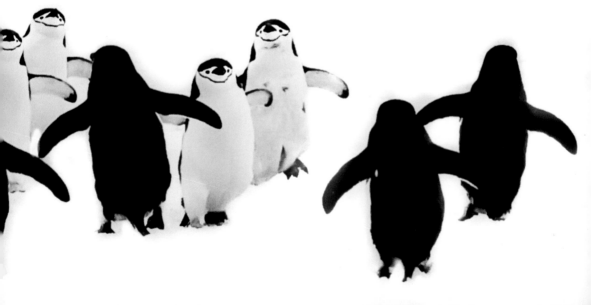

December

1 Monday

St Andrew's Day, Holiday (Scotland)

2 Tuesday

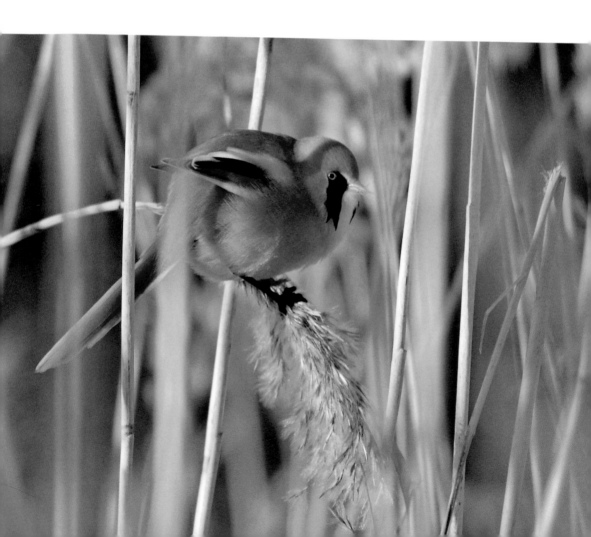

3 Wednesday

4 Thursday

5 Friday

6 Saturday

Full moon ○

7 Sunday

Golden moment
by Malte Parmo
'The bearded tit,' says Malte, 'is one of my favourite birds.' So he couldn't believe his luck when, while on a photography trip with his father to the Vest Amager wetland, close to Copenhagen, Denmark, they heard its characteristic psching call. 'Then something amazing happened – a flock of them landed right in front of me and started to feed.' Lit by the low December sun and dappled by the shadows of the reeds, this male wasn't at all bothered by his presence.

December

8 Monday

9 Tuesday

10 Wednesday

11 Thursday

Storm riders

by Ben Cranke

'Journeying across the Scotia Sea, our ship was battered by perpetual storms. I marvelled at the ease with which the petrels followed us into treacherous headwinds. As the light faded, I anchored myself to the stern railings, leaning out to photograph petrels riding the wind in the swirling wake of the ship.' The petrel relies on its excellent sense of smell to locate food and its diet comprises mainly krill, but also fish, squid and offal.

12 Friday

13 Saturday 14 Sunday

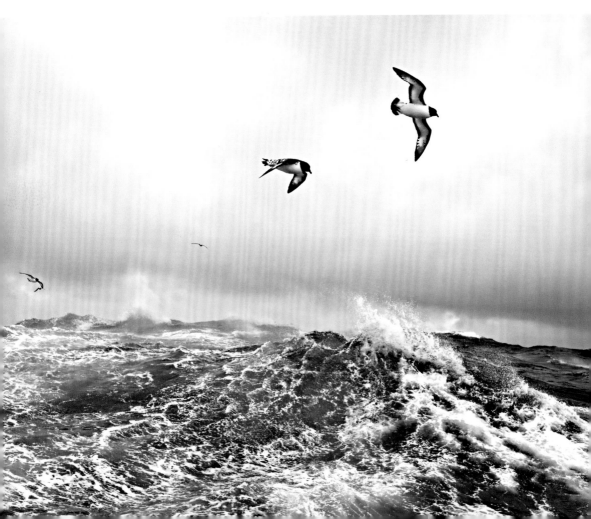

15 Monday

16 Tuesday

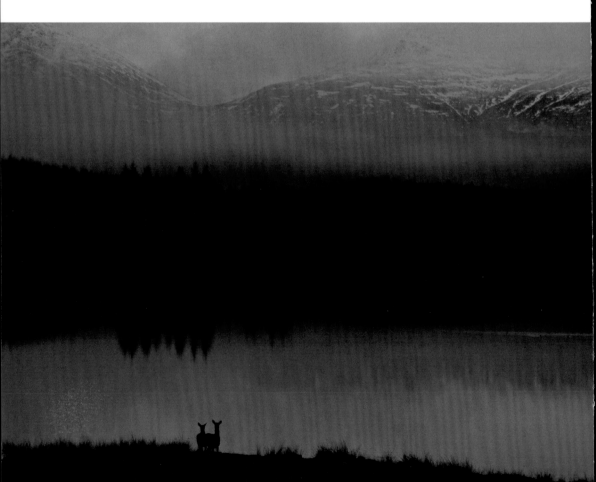

17 Wednesday

Chanukkah, Festival of Lights begins (Jewish)

18 Thursday

19 Friday

20 Saturday

21 Sunday

Winter Solstice

Deer at dusk
by Jack Chapman
'I headed to this loch hoping to get some landscape shots when I noticed red deer were gathering on the shore. I was trying out different compositions when it started to rain. As the clouds banked up on the mountains opposite, it created the moody atmosphere I was after.' Loch Garry, Scotland, is designated as a special protection area for its abundance of wildlife, where red deer are free to roam all year round.

22 Monday

23 Tuesday

24 Wednesday

Christmas Eve (Christian)
Chanukkah, Festival of Lights ends (Jewish)

25 Thursday

Christmas Day (Christian)

Territorial strut
by Ross Hoddinott
Southern Britain experienced an unusually cold spell in December 2010,
and Ross's Devon garden was covered in thick snow. 'The birds were feeding
at my bird feeder and were very tolerant of me. So I didn't need a hide
to photograph them,' he says. Ross captured this moment by setting his
exposure-meter so it wasn't fooled by the snow's brightness and using a
shutter speed fast enough to freeze the movement, but slow enough to blur
the scattering snow.

26 Friday

Boxing Day, Holiday (UK, Rep. Ireland, Canada, Australia, New Zealand)

27 Saturday

28 Sunday

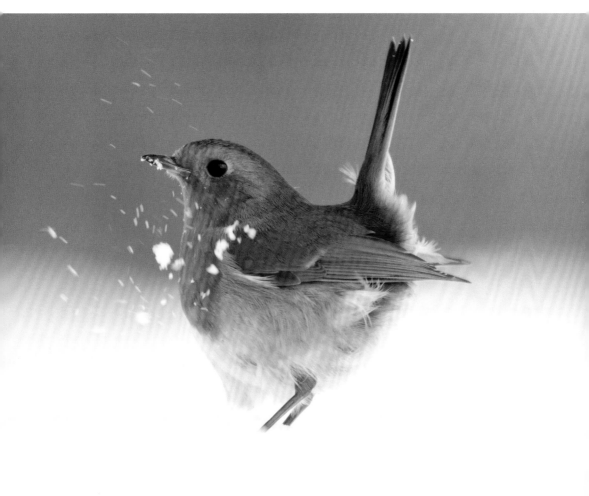

29 Monday

30 Tuesday

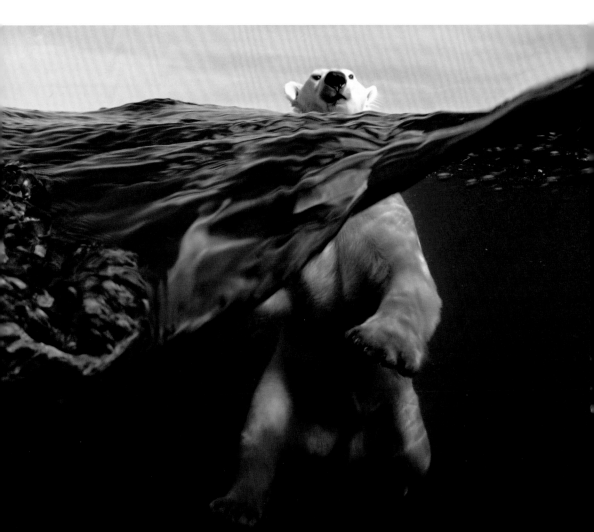

31 Wednesday

New Year's Eve
Hogmanay (Scotland)

1 Thursday

New Year's Day
Holiday (UK, Rep. Ireland, USA, Canada, Australia, New Zealand)

2 Friday

Holiday (Scotland, New Zealand)

3 Saturday

4 Sunday

Polar power
by Joe Bunni
After three days looking for polar bears in Repulse Bay, Canada, Joe finally
got lucky. He slipped quietly into the water with just a mask and fins,
attached to the boat by a rope. The second after Joe took this shot, the bear
reached out and touched the camera dome with its paw and then turned
and swam away. Joe was left with this unforgettable split-level image –
symbolic, he says, 'of the power and elegance of a creature struggling to
survive in a fast-changing climate.'

Index of photographers

Week 52
Territorial strut
Ross Hoddinott
UK
info@rosshoddinott.co.uk
www.rosshoddinott.co.uk
Agent: www.naturepl.com
Nikon D300 + 120–400mm lens (at
400mm); 1/500 sec at f5.6; ISO 400

Week 13
Leopard descending
Ajit K Huilgol
India
ajithuilgol@gmail.com
www.wildandsavage.com
Canon EOS-1D Mark lll + Canon 500mm
lens; 1/80 sec at f8; ISO 400

Week 12
Grass strokes
Georg Kantioler
Italy
georg@kantioler.it
www.kantioler.it
Canon EOS 5D Mark II + 100mm f2.8 lens;
1/30 sec at f3.2; ISO 200

Week 22
Paradise performance
Tim Laman
USA
tim@timlaman.com
www.timlaman.com
Agents: akeating@ngs.org
www.naturepl.com
Canon EOS 5D Mark II + 600mm f4 lens;
1/180 sec at f5.6; ISO 800

Week 14
The orphans
Mark Leong
USA
lmrk@aol.com
Agent: www.reduxpictures.com
Nikon D2x + 17–35mm f2.8 lens; 1/50 sec
at f7.1; ISO 100

Week 45
Desert icon
Chris Linder
USA
chris@chrislinder.com
www.chrislinder.com
Nikon D700 + 14–24mm f2.8 lens; 30 sec
at f2.8; ISO 3200; Gitzo GT3540LS tripod +
Kirk ballhead

Week 25
Fading beauty
David Maitland
UK
david@davidmaitland.com
www.davidmaitland.com
Agents: www.gettyimages.com
www.naturepl.com
Canon EOS 5D Mark II + 70–200mm f2.8
lens; 1/160 sec at f11; ISO 50

Week 48
Back in, front out
Esa Mälkönen
Finland
esa.malkonen@luukku.com
www.malkonen.fi
Canon EOS 7D + 300mm f2.8 lens; 1/2000
sec at f11; ISO 1600

Week 32
A marvel of ants
Bence Máté
Hungary
bence@matebence.hu
www.matebence.hu
Agent: boglarka@matebence.hu
Nikon D700 + 105mm f2.8 lens; 1/200 sec
at f10; ISO 640; SB-800 flash

Week 39
King of the vultures
Bence Máté
Nikon D300 + Sigma 300–800mm f5.6 lens;
1/4000 sec at f8; ISO 800; Gitzo tripod

Week 24
White fella
Marc McCormack
Australia
panomack@bugpond.com
www.marcmccormack.com
Canon EOS 1D Mark III + 600mm f4 lens;
1/1600 sec at f13; ISO 250

Week 19
Ethiopian mountain king
Joe McDonald
USA
info@hoothollow.com
www.hoothollow.com
Canon EOS-1D Mark III + 500mm lens;
1/200 sec at f4; ISO 640

Week 8
False killers, disguised dolphin
Clark Miller
USA
clark@aquaterraimagery.com
www.aquaterraimagery.com
Canon EOS 7D + Tokina 10–17mm lens at
13mm; 1/100 sec at f8; ISO 320; Nautican
housing + Zen dome port

Week 29
Nature's canvas
Francisco Mingorance
Spain
jfranciscomingorance@gmail.com
www.franciscomingorance.com
Nikon D3 + 70–200mm lens; 1/3200 sec at
f4.5; ISO 400

Week 35
Lanzarote by moonlight
Francisco Mingorance
Nikon D3 + 24–70mm lens; 740 sec at f3.5;
ISO 200

Week 15
Elephant onlooker
Juan Carlos Muñoz
Spain
jcmunoz@artenatural.com
www.artenatural.com
Agent: www.naturepl.com
Canon EOS-1Ds Mark II + Canon 100–
400mm lens; 1/60 sec at f5; ISO 400

Week 5
Ocean abstraction
Laurence Norton
USA
laurence.norton@gmail.com
www.laurencenorton.com
Nikon D3x + 28–300mm f3.5–5.6 lens +
2-stop circular polariser + 3-stop ND filter;
0.6 sec at f20; ISO 50

Week 49
Golden moment
Malte Parmo
Denmark
mail@parmo.org
www.parmo.org
Canon EOS 450D + 70–200mm f4 lens +
1.4x converter; 1/500 sec at f6.3; ISO 400

Week 20
Leaping heron
Thomas P Peschak
South Africa
Thomas@thomaspeschak.com
www.thomaspeschak.com
Nikon D3 + 70–200mm f2.8 lens; 1/3200
sec at f6.3; ISO 400

Week 23
Giant beachcomber
Thomas P Peschak
Nikon D3 + 14–24mm lens; 1/200 sec at
f22; ISO 200; Nikon SB800 flash

Week 3
The charge
Eric Pierre
France
eric_ep_pierre@yahoo.fr
www.boreal-lights.com
Nikon D700 + 500mm f4 lens; 1/2000 sec
at f8; ISO 400; tripod

Week 17
Little hopper
Alexandr Pospech
Czech Republic
a_pospech@yahoo.com
www.photographypospech.com
www.facebook.com/ConservationPhoto
Canon EOS 40D + Canon MP-E65mm f2.8
1.5x macro lens; 1/250 sec at f11.3; ISO
100; flash

Week 42
The salsify canopy
Ana Retamero
Spain
retamero.olmos@gmail.com
www.anaretamero.com
Nikon D70s + Nikkor 105mm f2.8 lens; 1/40
sec at f14; ISO 200

Week 47
White-out
Stephan Rolfes
Germany
stephan_rolfes@hotmail.de
Nikon D300 + AF-S VR Zoom-Nikkor
200–400mm f4G lens at 280mm; 1/2000
sec at f5; ISO 400; tripod

Week 34
Tiger stalking
Andy Rouse
UK
andyrouse@mac.com
www.andyrouse.net
Agent: www.naturepl.com
Nikon D3 + 200–400mm lens; 1/1000 sec
at f4; ISO 500

Week 6
Hunting harrier
Marc Slootmaekers
Belgium
marc.slootmaekers1@telenet.be
Canon EOS 50D + 500mm lens; 1/1600 sec
at f4; ISO 400; Gitzo tripod + Manfrotto
503 Fluid Head

Week 28
Swamp heaven
Mac Stone
USA
macstonephoto@gmail.com
www.macstonephoto.com
Canon EOS 50D + 10–22mm lens; 1/8 sec
at f22; ISO 100; Manfrotto Magic Arm +
super clamp; Canon intervalometer

Week 16
Spirit of the Badlands
Joe Sulik
USA
joseph.sulik@me.com
Nikon D90 + 500mm f4 lens; 1/350 sec at
f11; ISO 400

Week 10
Hare sitting tight
Klaus Tamm
Germany
info@tamm-photography.com
www.tamm-photography.com
Canon EOS-1D Mark III + 600mm f4 lens +
EF 2x II extender; 1/125 sec at f9; ISO 500

Week 27
Lion among the shoal
Alex Tattersall
UK
alex@uwvisions.com
www.uwvisions.com
Canon 500D + 10–22mm lens; 1/64 sec at
f11; 2 Inon Z240 strobes; Patima housing

Week 2
Illusion
Stefano Unterthiner
Italy
info@stefanounterthiner.com
www.stefanounterthiner.com
Nikon D700 + 24–70mm lens; 1/320 sec at
f16; ISO 1000

Week 11
Wild spring garden
Floris van Breugel
USA
florisvb@gmail.com
www.ArtInNaturePhotography.com
Canon EOS-5D + Canon EF17–40mm f4L
USM lens; 1/4 sec at f16; ISO 200; polariser;
Feisol tripod + Markins M20 Ball Head

Week 26
Sweet intimacy
Christian Ziegler
Germany
zieglerphoto@yahoo.com
www.naturphoto.de
Canon EOS-5D Mark II + 17mm f2.8
lens; 1/60 sec; ISO 400; 6 flashes; remote
trigger; tripod

First published by the Natural History Museum, Cromwell Road, London SW7 5BD
© Natural History Museum, London, 2013
Photographs © the individual photographers
Text based on original captions used in the Wildlife Photographer of the Year exhibitions
ISBN: 978 0 565 09323 5